Contents

Sponsors

Arts Council of Great Britain

The exhibition has received generous financial support from Film, Video and Broadcasting: Great Britain Touring Fund and the International Initiatives Fund of the Arts Council of Great Britain.

Pioneer High Fidelity (G.B.) Ltd

Pioneer Electronic Corporation was founded in 1938 by Nozumu Matsumoto. Since the release of its first laserdisc players in the early 1980s, Pioneer has continued to offer innovative laserdisc-related products and applications for home, commercial and industrial use.

The Art of Entertainment

Art Services Management

Art Services Management, located in New York City, specialises in the international transportation of fine art for museums, galleries, artists and collectors. Established 1990, Art Services Management is dedicated to customised, high quality, personal service in the field of exhibition co-ordination, customs brokerage and international freight forwarding.

McCollister's Moving and Storage Inc. (USA)

McCollister's Moving and Storage is proud to be associated with the fine arts community. Our organisation has been involved in the packing, preparation and transportation of objects of fine art and antiques for three decades. Our reputation for unparalleled services has made us the mover of choice for the world's finest institutions.

Martinspeed Limited (GB)

Martinspeed Limited was established in 1975 as a specialist fine art packer and shipper and is jolly good at it.

Preface

Gary Hill's work has attracted increasing attention in the last five years, and is now being shown internationally in a range of one-person and group shows. Both the Museum of Modern Art Oxford and Tate Gallery Liverpool have played an important role in bringing video work to larger audiences, and it seems natural that Gary Hill's first solo exhibition in the UK should be the result of our collaboration.

The remarkable power of Gary Hill's work derives from the visceral connection between its form and its subject. The stripping away of technical or aesthetic intermediaries makes for a direct hit on the viewer's sense of place and being. Thresholds of images and sounds interweave and seemingly mirror our own questions about our bodies and the nature of thinking and perception.

We have organised this exhibition around a group of installations that, if not completely silent, directly confronts silence as the field where the 'Other' comes into play. Those sounds that remain are underscored by the very silence they mark. Compared to Hill's work as a whole this selection – 'Inasmuch as It Is Always Already Taking Place', 'I Believe It Is an Image in Light of the Other', 'Tall Ships', 'Between 1 & 0' and 'Learning Curve', all from 1990-93 – emphasises the body and writing, and all but eliminates the spoken word. Speech and dialogue, with their tendency to suggest narrative, are suppressed in favour of the more material qualities of writing, non-linguistic sound or noises, and the physical presence of the artist and viewer.

We greatly appreciate the time and thought given to this show by Gary Hill, and the support given to the project by Donald Young and the staff at Donald Young Gallery Ltd. We should also like to thank Gary Hill's assistants, Paul Kuranko and Mark McLoughlin, and George Quasha and Charles Stein for coming to perform at the exhibition's opening seminar at Oxford.

The exhibition has received generous financial support from Film, Video and Broadcasting: Great Britain Touring Fund and the International Initiatives Fund of the Arts Council of Great Britain. We are indebted to Mr Yamamoto of Pioneer High Fidelity (G.B.) Ltd for the loan of equipment and to James M Opinsky of Art Services Management (USA) for his help with establishing a consortium for exhibition transport. In this group we would also like to thank Mr Daniel McCollister, President of McCollister's Moving and Storage, Inc (USA) and Tony Chapman, Managing Director of Martinspeed Limited (GB).

Chrissie Iles, Exhibitions Organiser,
Museum of Modern Art Oxford

Lewis Biggs, Curator,
Tate Gallery Liverpool

Introduction

Chrissie Iles

The work of Gary Hill operates in that area between our interior and exterior experience of the world. The construction of this experience takes place through language and the body, and it is the interrogation of these two elements which forms the basis of Hill's enquiry.

Raymond Bellour, in describing video as being a place of passage where ancient gestures, such as writing, change their meaning and become intertwined, epitomises the transformative nature of Gary Hill's work. Hill engages us in the observation of deeply engrained, archetypal experiences – reading, writing, the utterance of primal sounds, the naked body. Their ancient resonance, channelled through the complexity of new technology, reveals the core of what constitutes our consciousness, our very identity as human beings.

Hill's juxtaposition of language with the body to explore the fabric of our conscious selves makes this exhibition of particular relevance to many British artists working with video and new media. A number of women artists in particular have articulated interior experience by physically externalising the internal organs of the body, linking verbal expression and writing to bodily explusion. Automatic writing, infantile speech and primal utterances have also been used to create a space for otherwise silent, marginal voices.

Hill's work offers a similar questioning of the borders of socialised language, but in more universal, existential terms. The skin of the body and the surface of the video screen remain intact. It is the video equipment itself which is stripped away, in a reverse process of dismantling from without. Screens are

stripped of their surround; images are projected down from inside metal cylinders suspended from the ceiling. The frame of the image becomes not a screen but, for example, the page of an open book, within which Hill's naked torso slowly turns. The images seem not to belong to video. Their source becomes mysterious, no longer wedded to technology but emanating from some secret place.

From wherever the image appears, the body in Hill's work is fragmented. Its presence is thereby dislocated, and through the artificial construction of a collaged image, a parallel absence occurs. The co-existence of absence and presence suggests a relationship between the self and the world at once distant and intimate. This is the hallmark of Hill's work, and of desire: The longing for, yet impossibility of, union with the other.

This longing is suggested in the merging of an image of Hill's body with an image of text projected onto an open book in 'I Believe It Is an Image in Light of the Other'.

All appear to become a single entity. Yet this doubling, or mimicry, is artificial, like an animal using camouflage to fuse momentarily with its environment – here, an imaginative space. As always, Hill holds the real and the imaged apart.

Spoken language should be able to bridge this distance. Yet where it occurs in this exhibition it is in a primal form: unintelligible, half-hidden, forcing our ear into an aurally voyeuristic posture as we strain to understand it. From the tiniest monitor in 'Inasmuch as It Is Always Already Taking Place', the faint sound of a preoccupied, whispered muttering can be heard as the tip of a thumbnail

scratches at the fragment of text. As Lynne Cooke has observed, speech in Hill's work often seems to come from the depths of the body, operating not as an instrument of communication but as the bearer of something beyond words.

Another level of meaning beyond words can be evoked by silence. In these five installations, silence predominates. The absence of speech allows the body's own language to come forward. In 'Tall Ships' our movements become the text of the piece. The neutral impassiveness of the projected figures walking silently towards us causes our own reactions to be involuntarily triggered, just as someone's silence may prompt us to fill the space with words. In 'Tall Ships' the artist has transferred his physical struggle with language in earlier works to the viewer. We cannot help our instinctive reactions as we begin to engage with the individual images of the different people facing us in the darkness. The piece becomes a mirror through which we are brought face to face with our unconscious responses to other people.

To be able to scrutinise a complete stranger in such close proximity is a uniquely intimate experience. Yet the impossibility of connecting with them forces us to confront yet again, simultaneously, that double-bind of intimacy and distance. We are, in Blanchot's words, 'locked in an essential solitude'. In the darkness of the corridor we ourselves become half of yet another kind of double image. Freud wrote of the double as being connected 'with reflections in mirrors, with shadows, guardian spirits, with the belief in the soul and the fear of death. Probably the "immortal" soul was the first "double" of the

body'. In their removed distance, the ghostly images remind us of our own fleeting mortality.

In the haunting silence of 'Tall Ships' the presence of language still seems all-pervasive. Perhaps, as George Quasha suggests, our very presence is linguistic, because of the other language which the silence releases. In this group of Gary Hill's recent works the presence of speech and text has thus been replaced by another kind of experience of language. It is this new space which the exhibition occupies.

Gary Hill: biography

Gary Hill was born in Santa Monica, California, in 1951. He moved to Woodstock, New York in 1969 and studied at the Art Students League. Originally a sculptor, Hill began working with sound and video in the early 1970s and has produced a large body of both single-channel video works and mixed-media installations. Hill has received fellowships from the Rockefeller and Guggenheim Foundations as well as the National Endowment for the Arts; among the latter, a Japan/United States Cultural Exchange Fellowship. Since 1985 Hill has lived in Seattle where he established a video programme at the Cornish College of the Arts. In 1988 he completed 'Incidence of Catastrophe', one of several works he has made inspired by the writing of Maurice Blanchot. A residency at the Centre Georges Pompidou during the same year culminated in the making of 'Disturbance (among the jars)'.

Hill had his first gallery solo exhibition of video installations in 1990 at Galerie des Archives in Paris for which he produced the series 'And Sat Down Beside Her'. His 'Beacon (Two Versions of the Imaginary)' was part of the *Energieën* exhibition at the Stedelijk Museum in Amsterdam, a notable group exhibition for Hill in that it was the first time his work was seen within an overall contemporary art context. Since then, Hill has continued to work almost exclusively with installations, participating in a number of international exhibitions. At *Documenta IX* he premiered one of his most ambitious works, 'Tall Ships'. His 'House of Cards' 1993 was recently completed for *Strange HOTEL*, an exhibition held at the Aarhus Kunstmuseum in Denmark. 'Between 1 & 0', also of 1993, travelled to Seoul, Korea as part of the 1993 Whitney Biennal. Hill's first major exhibition of installation works in the United States opens at the Hirshhorn Museum, Washington DC in February 1994. Organised by the Henry Art Gallery, Seattle, the exhibition will subsequently tour the States.

List of works

Inasmuch as It Is Always Already Taking Place
1990
16-channel video/sound installation
Sixteen 1/2" to 23" black and white
television tubes positioned in horizontal inset
in wall
Collection Lannan Foundation, Los Angeles

Sixteen modified video monitors of various
sizes, all removed from their casings, are piled
in a niche, 50 to 120 cm high, like a collection
of stones. Each monitor focuses on different
parts of the human body, accompanied by
the sound of pages turning, murmuring, and
the rubbing of hands.

I Believe It Is an Image in Light of the Other
1991-2
Mixed media installation
7-channel video, modified television tubes for
projection, books and speaker
Collection Stedelijk Van Abbemuseum,
Eindhoven

The projection elements consist of seven
modified video monitors and projection
lenses placed inside seven black metal cylin-
ders which hang from the ceiling. The only
source of light in the darkened room is from
the images of different parts of the male
body, and a chair, projected onto open books
lying on the floor. The texts illuminated by
the images are excerpts from *The Last Man*,
by Maurice Blanchot

Tall Ships 1992
16-channel video installation
Sixteen black and white monitors, sixteen
projection lenses, sixteen laserdisc players and
computer-controlled interactive system
Collection Lannan Foundation, Los Angeles

Down a completely dark, 30 metre long
corridor-like space, sixteen black-and-white

images of people, varying in ethnic origin,
age and gender, are projected directly onto
the walls. No border of light defines the
frame of the images: only the figures them-
selves give off light into the space. The last
projection is on the back wall, at the end of
the corridor. From standing or seated postions
ranging from one to two-feet high, the
figures are first seen in the distance at
approximately eye level. As the viewer walks
through the space, electronic switches are
triggered, and the figures walk forward until
they are approximately lifesize. They remain
in the foreground, wavering slightly, until the
viewer leaves the immediate area. Since all
the projections are independently interactive,
any number of figures can be in the distance,
walking toward or away from a viewer, or
standing in the foreground, depending on
the number of viewers in the space.

Between 1 & 0 1993
2-channel video/sound installation with
thirteen 14" modified monitors, computer-
controlled video switcher, two speakers and
aluminium structure
Courtesy Donald Young Gallery, Seattle

Using a small hand-held camera, the artist
recorded his own body, scanning himself at
extreme close-up range. The images are
switched horizontally and vertically upon 13
monitors (cathode ray tubes mounted on an
aluminium structure) that appear as if they
are being rubbed or etched onto the screens.
The configuration of the monitors can sug-
gest a Greek cross, a first aid sign, or the
mathematical plus sign, all of which never
quite materialize as an image. The rapid
switching of the images (30 frames per
second) constructs extended images of body
parts – legs, arms, lips, a single finger, hairs
etc – that flow back and forth, up and down,
on several screens at once. The intersection of
the centre suggests the cross hairs of a looking

device attempting to locate a point or marker
on the body from whence one can begin. The
sound of graphite being scribbled follows the
switching movement of the images reinforc-
ing a physicality that is at once extremely
close and yet untouchable.

Learning Curve 1993
Single-channel video installation. Silent. Video
projector, plastic sheeting and plywood and
stainless steel chair/table construction
Courtesy Donald Young Gallery, Seattle

The first work in a series that uses the model
of a school chair with the attached desktop
that curves around the body. The table slowly
inclines extending out 5 metres and widens
to nearly 4 metres. At the end of the table a
slightly curved projection screen thirty inches
high is mounted at the edge. A moving image
of a perfect wave seen directly ahead
continuously enfolds upon itself and remakes
itself. At once homage to surfing and a
physical construct of the theory/practice
polemic, 'Learning Curve' becomes a
metaphor for the viewer's thinking process
mirroring the never ending becoming of a
wave.

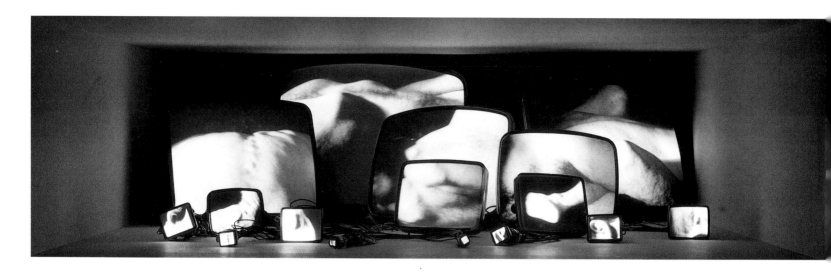

Naked to the sky
What you hide
What is veiled
All will be revealed

Time in the Body

Corinne Diserens

The first, Raphao, began by creating the head;
Abron created the crown, Meniggesstroeth created the brain
Asterekhme, the right eye, Thaspomakha, the left eye
Ieromunos, the right ear, Bissoum, the left ear, Akioreim, the nose, Banenephroum, the lips
Amen, the teeth, Ibikan the molars, Basiliademe, the tonsils, Akhkha, the uvula
Adabam, the neck, Kahaaman, the spine, Dearkho has the throat
Tebar, the right shoulder and the left shoulder, Mniarkhon, the right elbow and the left elbow
Abitrion, the right forearm, Euanthen, the left forearm, Krus created the right hand
Beluaé, the left hand, Treneu, the fingers of the right hand,
Balbel, the fingers of the left hand
Krima, the fingernails, Astrops, the right breast
Barroph, the left breast, Baoum, the right armpit, Ararim, the left armpit...

'Disturbance (among the jars)'

Gary Hill's video 'Incidence of Catastrophe' (1987-88) ends with an image of the artist's naked body curled up like a foetus. He is drained, exhausted. Every thing he has read – Blanchot's *Thomas L'Obscur* – has become physical symptom. He is haunted, trapped by the text, suffocating. Stammering, convulsive, his body has broken down – in a state of collapse close to Bataille's, that of a man emptied and thrust before destiny by a story read in a trance. He has become so caught up in the reverie that is the book that he can no longer stop reading. Drunk, he is adrift on the waters of the ocean that Thomas, where he sat, was already contemplating, and that recur at several points in 'Incidence of Catastrophe', the ocean from the beginning of 'Processual Video' (1980): 'he knew the ocean well'. Hill renews the theme of the voyage of initiation, and every journey in this world is an exploration of the mind. The body, which has become a wreck doomed to solitude, does not reside in the movements of waves but in uncertain, stagnant waters. The sea withdraws, life ebbs from him.

As sometimes with Eva Hesse,[1] the body is seen as a system that produces various evacuations, secretions and disjecta. Hesse noted in her journal: '...Revealing the past – and thus overcoming this shit – purging it by this entrance into the future – wholly and forever!!!' These final images of 'Incidence of Catastrophe' bring to mind Marcel Griaule's analysis of the ambivalent cultural status of spit, as both stain and purification:

Spit goes with breathing, which cannot leave the mouth without becoming imbibed with it. Now breath is the soul, so much so that some peoples talk of "the soul at the front of the face" which ceases to be when breath can no longer be felt. We say "to breathe his last", and "pneumatic" ultimately means "full of soul".[2]

'Incidence of Catastrophe' came about from having a unique and powerful experience while reading that particular book. As you read this book, it reads you. It personifies that kind of enfolding of physicality back onto consciousness that is so indigenous to video – there would have been no way not to have done something with it. Being the protagonist was not a choice. I wasn't about to verbalize my experience of this book to a third person; I wanted to confront this text and its body (the book) as another real body (myself). (Gary Hill)

As Bachelard suggests in *La poétique de la reverie (On Poetic Imagination and Reverie)*, if we accept the hypnotic effect of the page of poetry, our remote dreaming self is restored to us. A kind of psychological memory, which brings back to life the Psyche of old and recalls the being of the dreamer we once were, sustains our reading dream. The book has spoken to us of ourselves.

...But what are we seeking in artificial paradises, we who are mere armchair psychologists? Dreams or daydreams? Which documents are the most vital to us? Books, always books. Would these artificial paradises still be paradises if they were not written? For us readers, they are paradises of reading.
...Yes, before the advent of culture, the world dreamed abundantly. The earth gave birth to myths and myths opened the earth so that its lakes could gaze like eyes at the sky. A high destiny rose from the abyss. At once, myths found human voices, the voice of man dreaming the world of his dreams. Man expressed the earth, the sky, the water. Man was speech and spoke for the

macro-anthropos that is the monstruous body of the earth. In primitive cosmic reveries, the world is a human body, human eyes, human breath, human voice.

Again, washed ashore by the waves, it is the body that reads, but this time it is fragmented, decentred in a 'reflexive space of difference through the simultaneous production of presence and distance' (Hill) which we also come upon in 'Inasmuch as It Is Always Already Taking Place', which comprises sixteen cathode ray tubes – light emitting elements of television monitors, of various sizes between 1/2" and 23", niched in a wall, their frames filled with life-size images of parts of naked body. Only one, very small monitor shows the image of a text with a finger following the movement of reading. The gaps between these 'naked monitors, their glass organs exposed'[3] vary, and yet they appear to form a single whole, one that radiates a cold light, that murmurs and breathes in the depths of the wall. The light shines out of the abyss, all that shines sees.

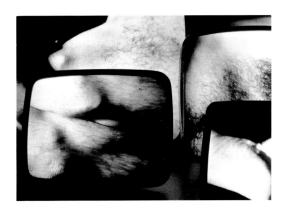

In her remarkable essay, 'Gary Hill: Beyond Babel',[4] Lynne Cooke notes that:
'Inasmuch...' posits a very different form of absence, one that reconfigures this notion of loss of centre into an impregnable solitude... This tableau is accompanied by a barely audible soundtrack on which a murmuring voice pulverised into what Hill calls "the debris of utterance" is almost obliterated by the rustle of turning pages and other ambient sounds. This ceaseless yet indecipherable monotone in which phrases seem simply to spill out of the mouth by rote serves to draw the spectator close to the chamber in which the monitors have been arrayed like still life elements.

This is not the body of 'Incidence of Catastrophe' – 'like a drowning man who goes down with his hands clenched, as one drowns because unable to lay one's body down as peacefully as in bed...'.[5] In 'Inasmuch...' life

does stretch out within him: it is a more contemplative, hypnotic work, one that emerged after the Hill/Thomas experiment, and in which the body compels thought.

Writing about Michelangelo Antonioni, Gilles Deleuze echoes Blanchot's words on fatigue and waiting:
The body is no longer the obstacle separating thought from itself – that which it must overcome in order to be able to think. On the contrary, it is that within which thought must plunge if it is to attain the unthought, which is to say, life itself. It is not that the body thinks, but that, in its stubborn obstinacy, it compels thought, forces one to think of that which eludes thought; life. Rather than life being summoned before the categories of thought, thought will be thrown into the categories of life. The categories of life are precisely the attitudes of the body, its postures. "We do not even know what the body is capable of" – be it in sleep, when drunk, in the midst of effort or when resisting. To think is to learn the potential of a non-thinking body, its capacities, its attitudes or postures. It is through the body, (as opposed to through the intermediary of the body) that cinema celebrates its nuptials with mind, with thought. "Give us a body, then": is first to set a camera on an everyday body. The body is never in the present, it contains the before and after, the fatigue and the wait.[6]

To set a camera on a body: that is exactly what Hill did in 'Crux' (1983-1987), when he fixed five cameras to himself. 'Crux' marks a significant return to the human body, which had disappeared from Hill's work after his early experiments with his own body and a video camera in the seventies. It marks the return of the artist as performer with the alternating roles of actor and medium, capable both of seeing and showing, and of being seen.

I must become a warrior of self-consciousness and move my body to move my mind to move the words to move my mouth to spin the spur of the moment. ('Site Recite: a prologue')

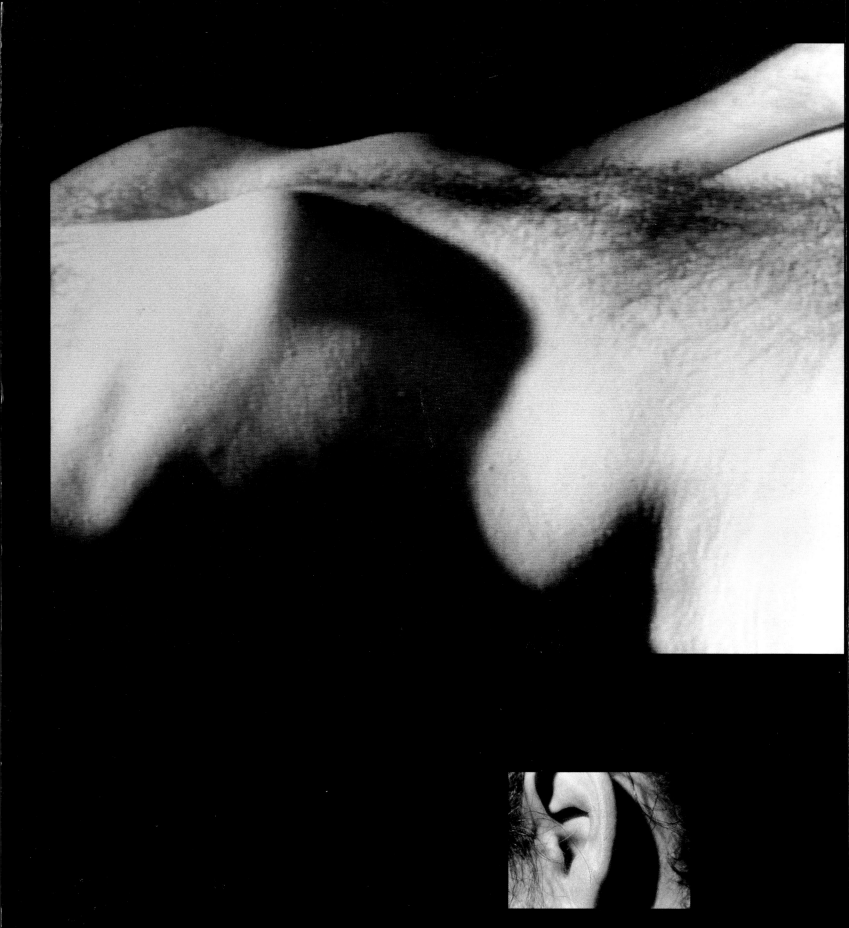

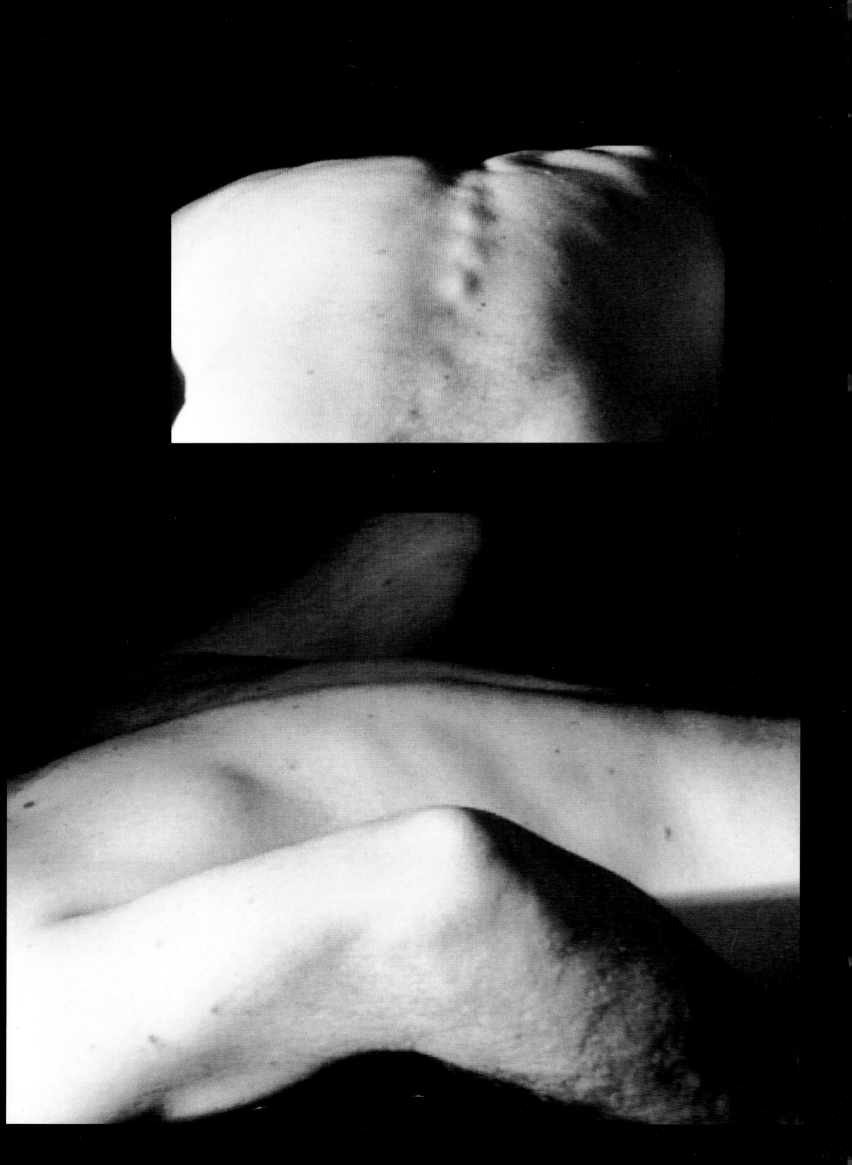

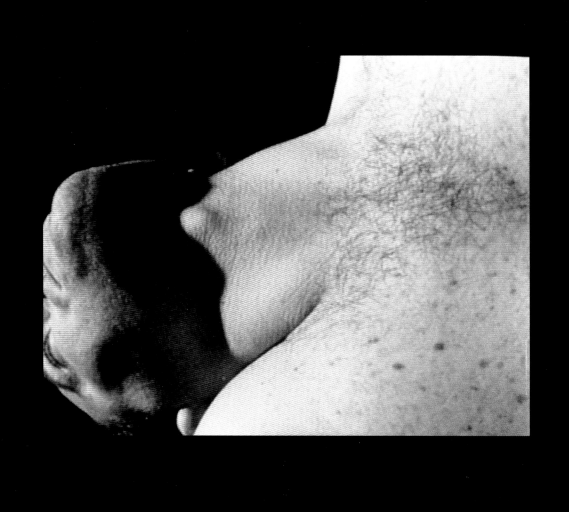

The idea is not to follow and track down the mundane body, but to have it undergo a ceremony which affects both sounds and gestures, making the body a grotesque from which there then emerges a gracious body. It is the transition from 'Crux' to 'Incidence...' to 'Inasmuch...', in which the body finally floats, gently palpitates, murmurs, breathes – slowly, patiently, draining meaning to the end or the origin of language and being.

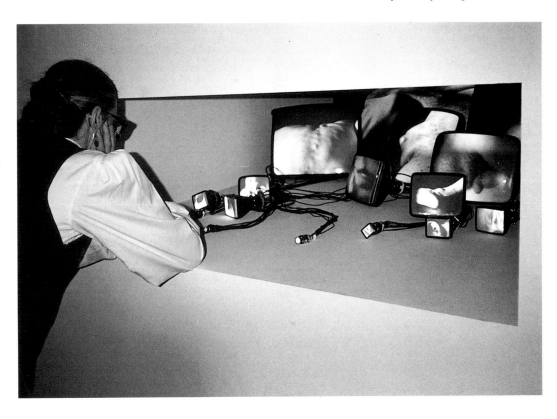

The direct time-image always takes us into that Proustian dimension of time in which people and objects assume an importance quite out of proportion to their spatial one. Proust talks in cinematic terms of Time setting its magic lantern on bodies and making different shots coexist within depth.[7]

Hill retains only that aspect of space which adheres to bodies. He composes his space from disconnected bits linked only by a single gesture. Here is his description of 'Inasmuch...':

 Their arrangement as such is one of accumulation – a pile up. They appear as a kind of debris – bulbs that have washed up from the sea. Each one is a witness to a fragment of a body – perhaps a reclining figure, a man reading, a corpse, etc – forever rendering actual size ad infinitum (ie a 1-inch tube displays a portion of a palm of a hand, or perhaps an unrecognizable terrain of skin; a 4-inch tube displays part of a shoulder or an ear; a 10-inch tube emits the stomach and so on). Each emission bares little movement (whether it be a wavering gaze or the murmur of the body remains unknown). The movement objectifies itself within a closed loop with no beginning and no end. The anatomical site is incessant, however fragmentary. [8]

The expression 'pile-up' recalls W S Wilson's analysis of the work of Eva Hesse: .
 She conceives of art (and life) as an investigation, construction – in the etymological sense of the word (from *struere*, to pile up, and *con* – which implies with or together) and as knowledge*: the subject constitutes itself in experience, it comes into being in the event of the work; the event as the emergence of a form/movement, of a form in movement, in-finite and derisory as well as necessary.[9]

In Hill's work, attitudes and postures turn towards that slow theatricalisation of the body Deleuze spoke of in relation to Morrissey and Warhol and Cassavetes, with his fatigue and waiting but also the moment of relaxation and the play of the basic, fundamental body.

Here the work has undone history and action, and even space, to penetrate to the attitudes and categories that put time in the body, and thought in life. There is a process whereby bodies are constituted from the neutral image, the black or white screen. The problem is not the presence of bodies, but of a belief which could restore to us the world and the body from what signifies their absence.

Translated from the French by
Charles Penwarden

* Translator's note: the original French word for knowledge, *connaissance*, (which is close to co-naissance, or co-birth), brings out a further connection which the English word does not allow: between knowledge and construction, and knowledge and birth – the constitution of self.

NOTES

1. 'Marcher sun un fil', Catherine David and Corinne Diserens, in *Eva Hesse*, IVAM, Valencia/Galerie nationale du Jeu de Paume, Paris, 1993.
2. Op. cit.
3. 'Disturbing unnarrative of the perplexed parapraxis (A Twin Text for DISTURBANCE)', George Quasha, *Gary Hill, Disturbance (among the jars)*, Musée d'art moderne de Villeneuve d'Ascq, 1989.
4. 'Gary Hill: Beyond Babel', Lynne Cooke, *Gary Hill*, IVAM, 1993.
5. *L'impossible*, Georges Bataille
6. *L'image-temps*, Gilles Deleuze
7. Gilles Deleuze, op. cit.
8. *Otherwordsandimages*, Video Galleriet/Ny Carlsberg Glyptotek, Copenhagen, 1990.
9. *Eva Hesse*, op. cit.

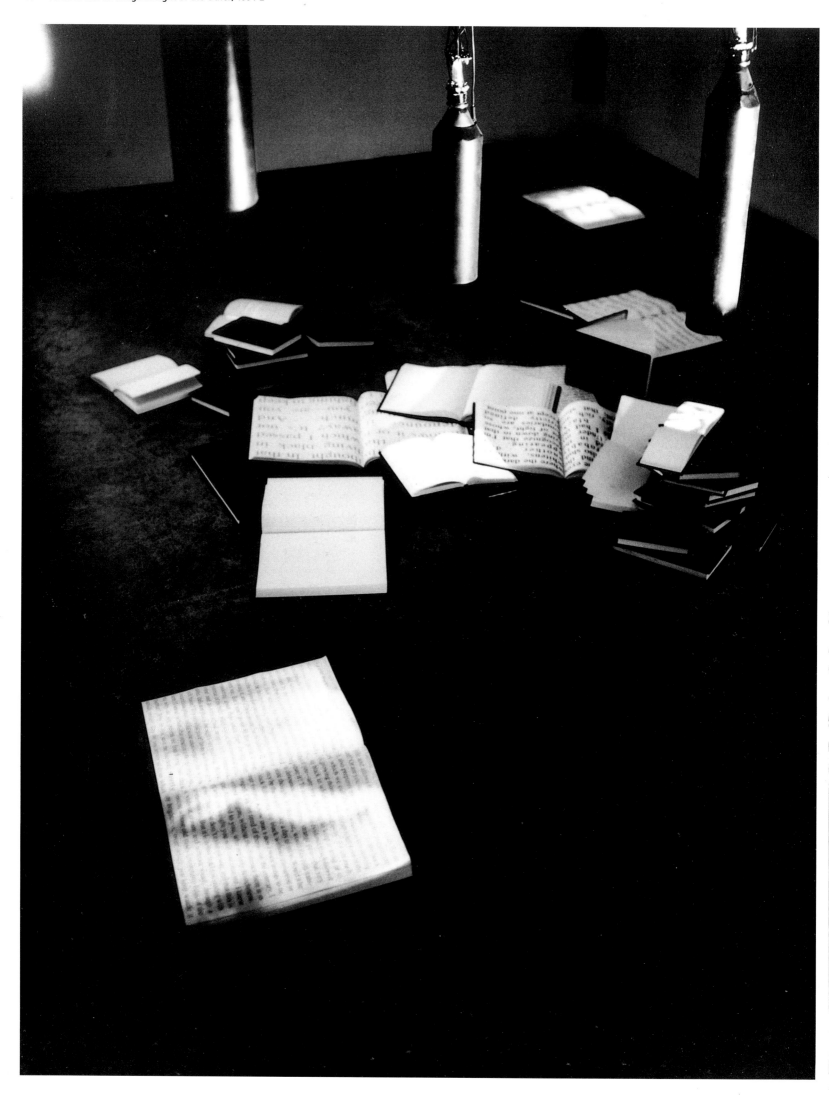

I believe (that) it is an image (in light) of the other

Bruce W Ferguson

We sink into the quicksilver of language – into its fluidity and into its fugitive, but authoritative, rank. Its gross status swallows us, complete. We become (some) body only when language inscribes our ephemerality, our death in advance. Our epitaphs are already written, waiting patiently for a breath without speech. We dream within images already drowning in a river of unconscious embraces; under the constancy of their currents and their satisfactions. Our immersed images are already foreshadowed by the technologies of vision and the engulfing history of profiles. We vanish with a trace.

At some point, when history and mythology were one by virtue of an untranscribed and unsigned collectivity, there may have been images which appeared suddenly on surfaces. By magic. A presentation prior to a representation. These images were the effects of a first cause. They came into being as primary case; as limit conditions of emergence. Such images displayed an imposition thought to be supernatural; evidence of forces unhuman, perhaps godly. They were, simply, projections

of faith resting on a chosen tissue. Illuminations which were wholly holy. No shadows of doubt.

And at some point, when history and mythology were one by virtue of a shared orality, there was only a language which sounded singingly to h(ear)ers. A body given rise to in voice and yielded to in the gut of another's flesh. A surfacing noise and a gradual sucking back to a torso's void from which another sound could re-emerge, again unrecorded. As Paul Valéry has written of noises or sounds (which must have become music to John Cage's ears), they spontaneously become immanent phenomena in us as '...a state of anticipation and creative suspense. We know at once that there exists within us a "universe" of possible relations...'.[1]

But such notions, if held at all today, seem nostalgic, anachronistic, unpoliticized, aesthetically cloistered and pseudo-poetically aspirant. Indeterminate and specious, even. Such capricious ideas (and any universal idea seems absurd now) about language and

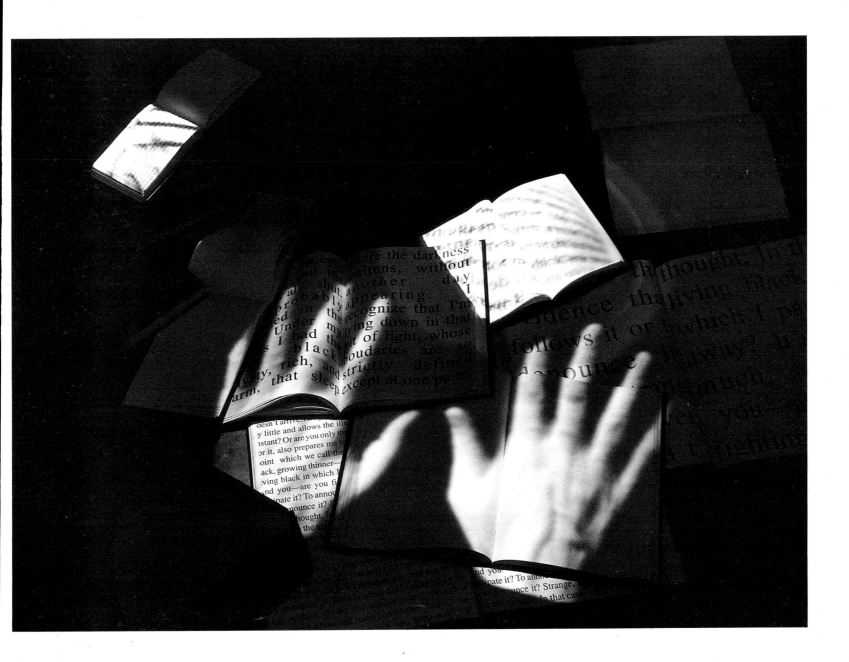

it also illuminates w

see lots of interesting de

curious about those thin

now we're over there. An

more likely to turn me away

be illuminated on all side

a ligh omes

images n push

then es them

any to you

illuminate, you

where the darkness wh

aring. I recognize tha

ht, whose boudaries a

remember: the

is also shut. It prob

er my eyelids I had the

warm, that sleep prese

appearing behind them

parts of m

went on for a long

close to the black, ma

lightly I watched

uld lose its c

se the final white

dead. Maybe

others it als
minates with an even light
f interesting details out the w
bout those things: it's enough
there. And my curiosity would
e away from here. It is a great d
all sides this way, at every inst
from now
en p hem away, attracts li
ay.. I'm that br
I'm incl
keep to you
whitens, without anoth
e that I'm lying down in th
s are so strictly defined e
eyes are shut, and th
ly happened in the room
he deep black, velvety,
reserves, that dreams alw
them; and no doubt I was
but the black
me, maybe
black, maybe in it
tly I watched for t
its color and i
whiteness to ris
Maybe this is the

images seem careless and unnecessarily mystifying when viewed under the scorching microlight of science, linguistics, semiotics and the ethical functionality that often, now, passes for art. For, we do not know 'at once' anymore, having been preceded and even, it is argued, overcome by language. We do not have the epiphanies of saints or even James Joyce. Instead, it is believed (almost universally) that ours is a life oversaturated with images mediated, predigested, regurgitated, re-presented and re-emanated in an ever-amassing accumulation which obviates any ideas of innocence and naivety. Accretion upon accretion of language and image events

and images, any sweeping rhetoric is gone forever, a victim of the endless history of everyday speech acts and the tongues of billions of subjects swarming in armies of enunciation.

Mythologies of origins (of etymologies, of beginnings, of disclosures) are then longings which are lost (myth only being depoliticized speech anyhow, if we grant Roland Barthes his argument). And Heidegger may have been correct that Language is the 'house of being' but Nietschze was already even more scathingly exact when he called it a 'prison-house' of sentences and structuring punishments. In our culture, reading and seeing are

frightfully comfortable about the a-literate notion that perhaps language is foreign, inexplicable, even apocalyptic at its roots. William Burroughs' aphorism that '... language is a virus from outer space' speaks of this dismay and this emancipation. This is the legacy of both surrealism and DADA; the legacy of poetics and its spaces. That language too can pass away and with it, its power. That language's jurisdiction, however lucent, can always fade. That a word spoken is under the command of structures, but it is always a word stolen at the same time. Lifted momentarily from the clasp of regulations and released. And that listening for gaps,

have suffocated and extinguished viscerality in the name of a specular and spectacular civilization.

And other languages have interpenetrated each other; other cultures have overlapped and justly infected each other; with images licentiously affiliating themselves to any and every word of any and every language, betraying earlier meanings for massive significations. The world is only context now, with each utterance and each image-sign a nodal point in a network of related relays of meaning. As Bakhtin says 'Every word gives off the scent of a profession, a genre, a current, a party, a particular work, a particular man, a generation, an era, a day and an hour. Every word smells of the context and contexts in which it has lived its intense social life; all words and all forms are inhabited by intentions'.[2] Any universal concept of language

over-regulated, overdetermined and overcast. The eyes have it. Sight means right.

Discontents, however, or flailings against the exquisite corpus of this overresolved and meticulous history of images and language do occur. Surprisingly antagonistic performances against the dour outlook described above do happen, spontaneously or with committment. And these dissatisfactions somehow keep alive the compelling or at least strangely attractive nonsensical idea that images are not of our doing – that they come from a source somewhere else. Perhaps, they say, images are as yet, not completely understood or maybe not even, ever, fully understandable. Perhaps, the vital presence of some images, even today, speak of even larger absences, of what cannot be shown. They remind us of the unspeakable and unshowable. And, too, there is something

apogees, ellipses and aporias is still insurrection. In short, that fiction is still at the centre of both language and images.

It is Gary Hill's aesthetic drive to exact from his installation 'I Believe It Is an Image in Light of the Other', a precise environment of contemplation for a contemporary indigenous state of images and languages. An oxymoronic return through sophisticated electronic communication devices to a space of indigenous ruins. Almost as though we could start again, expelled from the overdetermined historical forces of sinister syntax with its centres and closures and contents. As though the debasement of both images and languages (including all the avant-garde illusions of marginal strategies whose shadows reproduce the dominant forces even more; whose strategies reinforce the power already corrupted) could be, if not

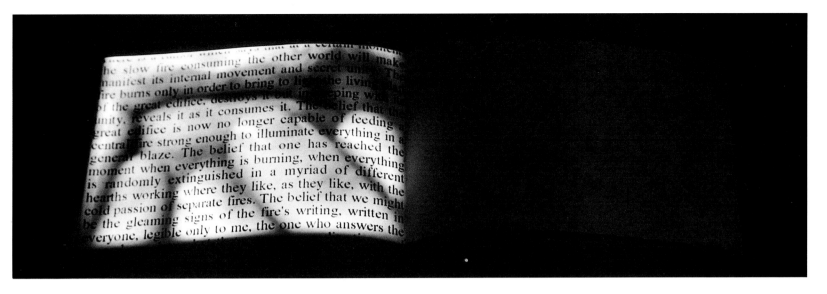

avoided, at least forestalled. Or, even better, this installation proposes that images and languages might be thought through; made porous and sinewy, so that their strengths and weaknesses are open to inspection, even autopsy. To re-manifest the authentic incantation in an image or a sound. To draw out the language that moves between them and make it available for, at the very least, a peripheral glance. To create an expectant space, unprivileged by previous knowledge; a resurrection made palpable. To reprieve a viewer/reader/writer with deference.

Through the integrity of video and sound technology, Hill interrogates language and images concomitantly, using each to purchase a fleeting hold on the other (the 'Other' that always casts doubt on the 'Belief' in the title). The complex audio-visual systems at work are teased by their own electrical flows to pulsate each discourse with its own breath of temporality. To make mouth images rustle like paper and chairs turn in a feat of appearing and disappearing like a page's novel memory. To steal the torment from both (the torment of an 'infinite relation' in which, as Michel Foucault says, there are always more things than there are words for them) and return to each its restorative power. To each its concentration. To take a dose of their own medicine.

Through the phenomenology of a viewer's choreographed experience, this installation actualizes, as it authors, an ancient Möbius circuit of body, speech, word, and image. 'I Believe..' grounds a domain, a typology, which is here and now (present) and then and there (re-present) simultaneously (by the 'grace' of technological sensitivity). It speaks to and of and from and by and within and through the perfect contamination of images and language which make of each other imperfect vehicles.

If images and language perform as a (secular) relic of the Real as its only material

attachments, then here we can see, in this remarkable installation, that their authority was always an illusion, always a fabrication of each discourse's imagination and interdependence. Images without language are stranded as Walter Benjamin taught, incapable of relay or anchor. They are strangely mute without a wordy frame to decoratively constitute them. And a language without images is finally impossibly bereft – cold, enumerative and arithmetic at best. And certainly empty of persuasion. Yet, for just a moment in our consciousness while gliding or stumbling through this darkened space of typographical and body part images and floating texts coming in and out of view, Hill allows us to contemplate an image outside of language by showing language as the horizon for any visual figure. As its foreground and its foreshadow. And language, which he has abstracted from its connotative power, becomes imagery as the polar physicality of its ephemerality; as its muscular thorax of almost-speech. Language becomes picture of language, a still life of words (and types). Or another way of saying the same thing is that 'I Believe It Is an Image in Light of the Other' is a physical plea for a passionate place that might exist even as it inevitably admits to us and itself that it is not that place. Just as it inevitably collapses back into the dialectical parameters of the 'infinite relation', it sustains a momentary space, a performative moment of non-translation.

This installation outstrips both criticism and description, defying any language, including pictorial, to comfortably or comprehensively deal with an experience which relies entirely upon the presence of the viewer in an authentic and engaged relation to the work. 'I Believe...' gently mocks its own abilities to convince even as it challenges the authority of images and languages that it does use convincingly. This oscillating movement from authority to doubt, from illusion to presence,

from caution to copiousness, from sound to silence, from representation to presentation, suddenly conjures up surprisingly different viewers. The watcher, walker, bender, reader, dancer is spun into a slow web of insistencies and urgencies outside of easy theory and experience. 'I Believe It Is an Image in Light of the Other' reveals image and language as twin shrouds in the haunted house of description and interpretation. As silenced twins which point at each other in accusations of incompleteness. They are as unavoidable as the condition called human which they attempt too often to grasp too quickly. The installation turns in sweeps and stutters and reads and speaks itself as a narrative of co-experience. Running rampant with an intelligence of its own, this is a thinking-language-machine which recalls nothing less than the primordial state. Nothing less than its beginnings as its means to an end.

NOTES

1. Paul Valéry, 'On Corot', *Degas, Manet, Morisot*, Pantheon Books, Bollingen Series XLV. 12, New York, 1960, p.141 (translated by David Paul).
2. Tzvetan Todorov, *Mikhail Bakhtin: The Dialogical Principle*, Minneapolis, 1984, p.57 (translated by Wlad Godzich).

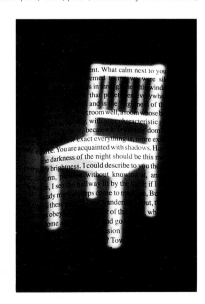

Missing persons

Stuart Morgan

Drawing back a curtain, the viewer enters a dark space. As the eyes accustom themselves to the darkness, the space turns out to be a long corridor, illuminated only by black-and-white images along its sides, and by a single image at its end. They are people, seen first in the distance, then advancing until they are lifesize. And though they are all different – men, women, younger and older people, finally, on the end wall on her own, a young child – they behave the same, approaching us curiously, as if we, not they, were the object of attention. The space itself is like a long gallery, and like a gallery, it allows us to be inquisitive. It is hard not to be; the images are easy to relate to. Perhaps this explains their apparent interest in us, for as moving portraits, they patrol a similar territory to our own, a fairly deep space where they approach and withdraw, examining us in every detail, taking time to reach conclusions or to satisfy their interest. For they want something, as they approach and confront us. And although we never realise what it is, by the end of their enquiry, their curiosity

seems to be satisfied. Only as we move on, we feel as if we have not got everything out of them that we might. And when, on occasion, they turn their backs and walk away, it is difficult not to feel rejected. What we sense, without pushing it to the forefront of our minds, is that they are responding to what we are doing. These people have something to do with us.

So distance, both literal and psychological, plays a major part in Gary Hill's 'Tall Ships', a work which depends on the fallacy that two-dimensional pictures can suddenly come to life. Our contemplation of them succeeds in making them do so, of course, whether or not we know how. (This Pygmalion fantasy may be as old as time itself, or at least dating from that hypothetical 'breakdown of the bicameral mind' which signalled or brought about the death of idols[1].) As in any study of images, the disturbing factor is the ease with which what is accurately perceived as a mute, lifeless object outside oneself undergoes a change. Empathy takes over and when that lapses, the artwork slips back into limbo

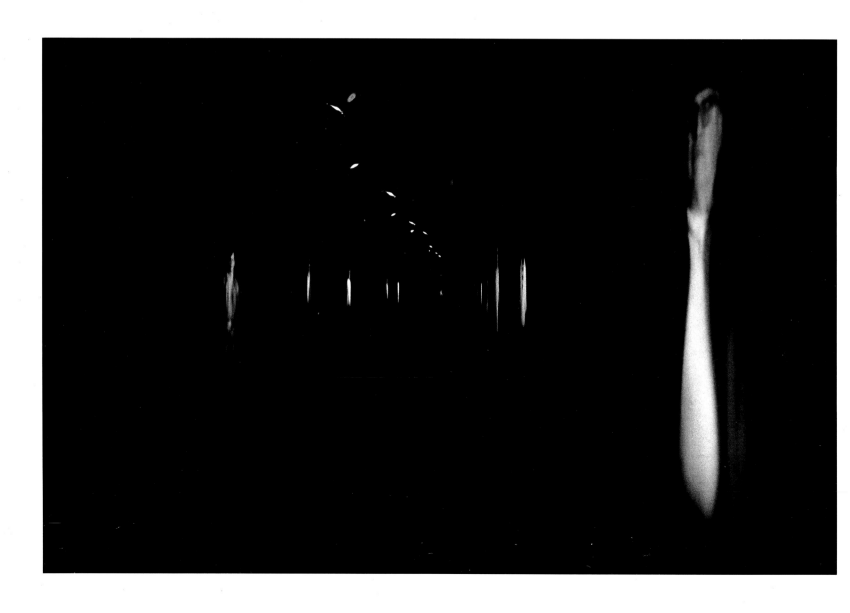

before another viewer approaches and confronts it anew. The language of art criticism gives too little evidence of this imaginative relationship with a work of art, a process which resembles the state of falling in love; always an exercise in potentiality and loss of definition, however temporary and safe. (Jean Cocteau had a habit of relaxing on a divan with his drugs, next to a large two-way mirror in which he could observe young men enjoying sex in the next room.) Surely the combination of safety and freedom, the pleasure of an imaginative foray and the emotional safeguards necessary to avoid involvement in such a situation reflect the reaction of any gallery-goer, in search of an experience which would, ideally, be unforgettable, but without the power to ruin one's own ability to repeat it at will. The vicariousness of the experience and the immediate exoneration it entails are paralleled in our own actions here. When we are tired of art, we simply walk away. The last thing we expect is that it will do the same to us.

'Tall Ships' brings into play the idea that pictures lead a life of their own, that they gaze back at us knowingly and that their apparent awareness sharpens our own perception of the fictional. That dramatic confrontation with a human image which seems to be taking an interest in us makes 'Tall Ships' a Mannerist work, for it not only centres on a conceit of image and reality, presence and absence – like those painted guards with drawn swords that suddenly become apparent on turning a corner at the Palazzo del Te in Mantua or the scene in Shakespeare's *A Winter's Tale* where the supposed statue springs into action – but also plays on the idea of the 'life' with which we invest images, hinting that they may be doing something similar to us. In this tussle between art and reality, the sides are equally matched. For sometimes the shadowy figures on screens before us seem as dubious about our identity as we are of theirs – and rightly so, for identity ebbs as the work proceeds. The development and subsequent lapse of their interest in us (and 'vice versa') has something cyclical and pointlessly promiscuous about it. Perhaps what is lacking in the figures who engage mutely with us, one by one, in 'Tall Ships', is a more particular type of recognition: that anagnorisis which so often clinches plots in drama and which in the 'real' world, at least, depends on our mutual realisation that we need to be parts of each other's lives. In

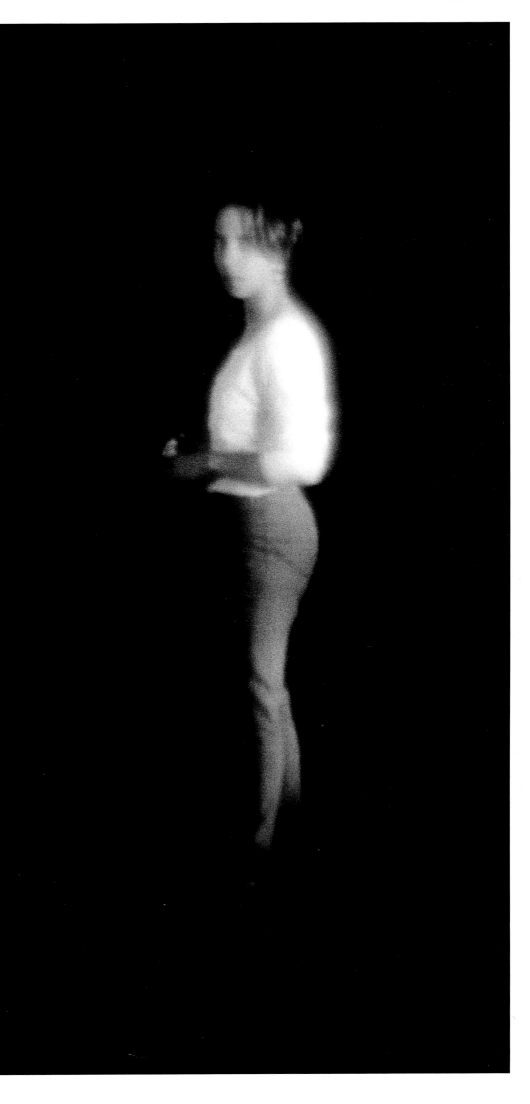

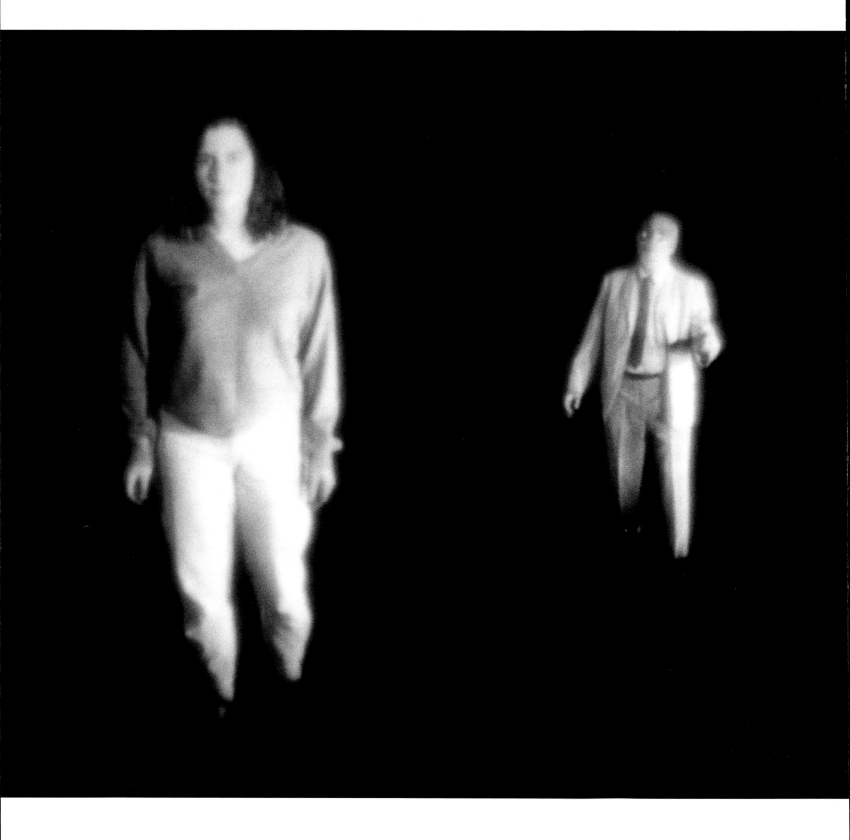

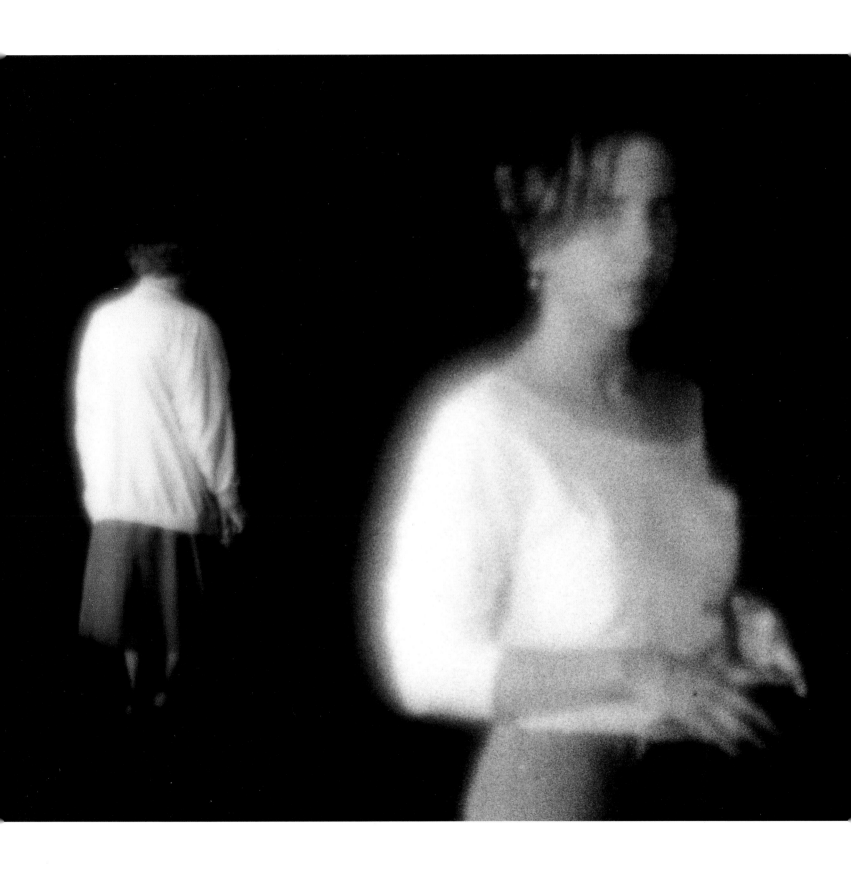

this case, nothing permanent will emerge; we are destined to be no more than 'ships that pass in the night'.

They do not pass without an investigation on our part: a human variation on the way animals prowl around each other. Looking, in this case, might be better described as looking *for*, making certain that not a single detail remains unexamined. As they change positions, then change again to cope with the object of vision from every possible angle, an opportunity arises to watch someone else watching. Are *we* the point of the investigation? The result is a growing unease coupled with a certain frisson, for we seem the object of extreme, concentrated scrutiny. The eyes seldom leave us. If a figure walks away, he or she will turn once, twice, three times, apparently to check some detail or to be reassured about an assumption. Moving from one image to another, and finding yet another figure engaged in the same prowl, growing larger as it confronts us and smaller as it departs, is a disconcerting experience. And a disappointing one, for there is a sense in which one's courtship and rejection by complete strangers is a test one seems on the point of winning but which finally fails. Yet of course the word 'finally' does not apply, for no two experiences of the work can ever be the same.

It is possible to distinguish differences between the behaviour of the figures. Their speeds, the directness of their confrontation, the distances they establish, differentiate them one from another. It is even possible to relate to them as types. Or supposed types; for in fact, these 'characters' are no more then mute ghosts, images flung onto a screen. 'Screen' is one word for it. What space does dream occupy, after all? A Kleinian might propose the breast to which babies are applied – an argument, therefore, in favour of concavity – not convexity, of course, for the baby's face is pressed hard enough against it to be surrounded by flesh. More recent theorists have argued differently; the 'dream screen' has a depth, they maintain, if only a shallow one, like the stage of a toy theatre. 'Tall Ships' seems to support this idea of a shallow stage. For the sense of being pulled up short in front of some invisible barrier is sufficiently powerful to suggest that communication may be the unifying theme of the entire installation. These figures have the same relation to us as the traditional idea of a ghost: sometimes a familiar, kindly visitor

who has arrived to check that everything is all right, at other times a presence intent on some kind of intervention, however obscure. There is one difference: while traditional ghosts seem knowing, experienced presences who return to places they know well, these people exist in a state of limbo. Unable to go any further, they seem to regard the screen as a frustration, and our world as a source of curiosity.

Being confronted by these strangers is one thing. Being interrogated by them, even in

silence, is quite another. No communication is really possible between image and viewer; they remain alien to each other, despite an understandable mutual attraction. Encounters get us nowhere. Art's purpose is to understand ourselves and society better. That, at least, is the traditional humanist point of view, a view in which motives such as an urge for reconciliation and equality play a major role. This urge is central to the experience of 'Tall Ships', which derives its power from the frustration of this need. Real viewers and images exist on such different and even antipathetic planes, this work suggests, that no reconciliation is possible. Any meeting that might take place is hindered by a feeling of awe and strangeness on both sides, and as the end of the sequence of images is reached, a feeling of stasis sets in. Instead of resembling a person appearing in a doorway, for example, the decrease in mobility makes the effect resemble that of a shallow grave. Gradually, as its occupant becomes that

much nearer, more present to us, a sense of the sepulchral permeates the entire work. The links between photographically produced images and death have often been discussed. The disturbing prelude to the final, more static images involve people checking our presence, registering the slightest detail, hovering, looking for something, and the feeling that we the visitors are interrogated only increases. For death is the end of and the reason for our interrogation.

The silence of the darkened space; the ghostly aspect of the figures who choose to examine us in an art gallery instead of our examining them; the increased stasis as the viewer moves through the room... Almost every aspect of 'Tall Ships' indicates a dual preoccupation with death and identity: death because a moving image thrown on a screen has only virtual existence, identity because that very problem seems in the forefront of the minds of the figures who make their appearances before us and, never quite satisfied, it seems, return time after time to revise their initial conclusion. The regularity of their approach, the growing familiarity of the presences, the choreographic aspect of the movements to and fro, their turns and returns, present a visual demonstration of that postponement which characterises the work itself as well as our approach to it. When Odysseus sails too far toward the edge of the world, he and his men are forced to make a libation to the dead, who approach them and try to hold conversations. (Their voices, says Homer, sound like dry leaves.) Alarmed, homeless, they are not as we would prefer to imagine them. The result is a postponement; that *anagnorisis* or 'recognition' that should result from such an encounter, is put off, and one master-plot, of 'knowledge, its loss and recovery'[2] is avoided. Perhaps the figures we see in 'Tall Ships' with their regular approaches and retreats hint at a similar avoidance of the facts of death. And maybe, as its name suggests, the work itself has parallels less with art than with other activities – with our own comings and goings – with rituals, with sports and with the games we play, unknowingly, as children.

NOTES

1. Julian Jaynes' term in his *The Origin of Consciousness in the Breakdown of the Bicameral Mind*, Boston, 1990
2. Terence Cave, *Recognitions: A study in Poetics*, Oxford, 1990, p.235

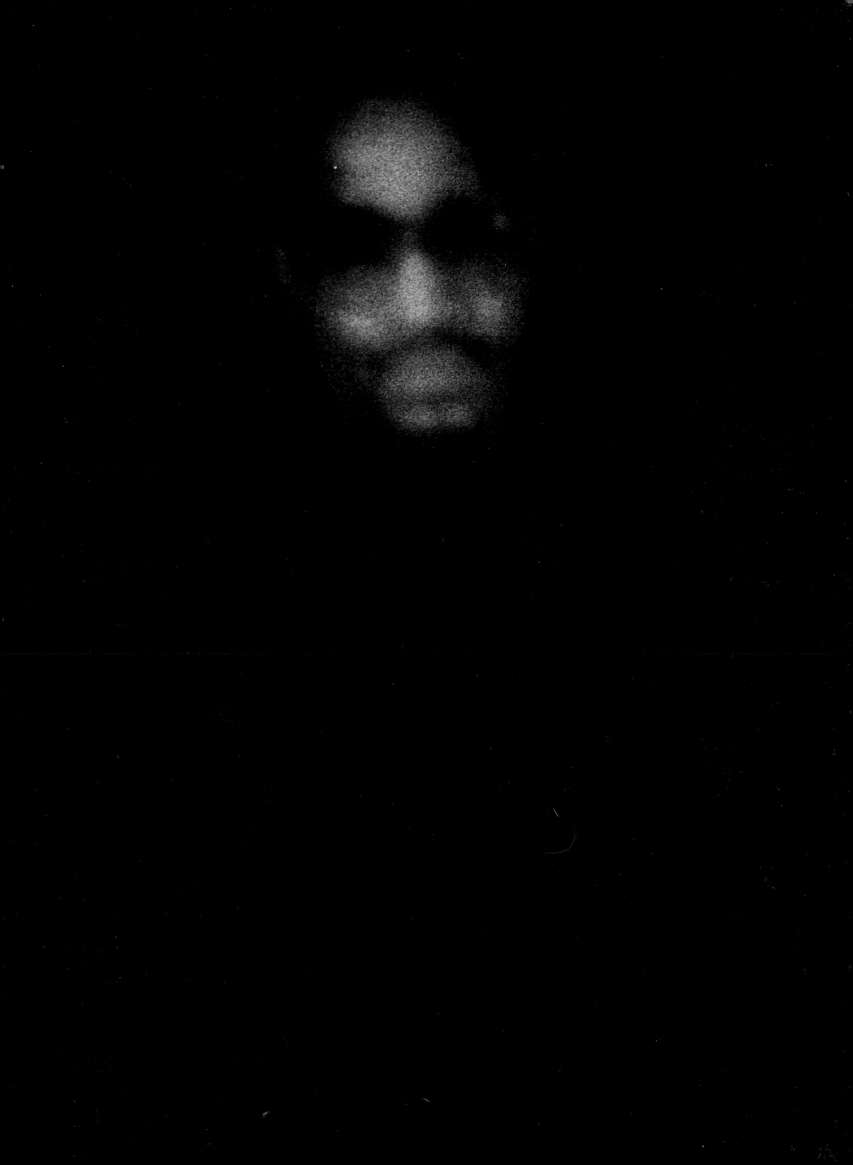

Between 1 & 0:
Script, Scribble, and Scratch

Lars Nittve

As I think about Gary Hill, it strikes me that what fascinates me about his work, as much as the work itself, is the viewer's encounter with it. I'm remembering last summer's extended, intense, intimate entanglement between visitors to the Rooseum and Hill's 'Between 1 & 0'.* I'm not sure I can still separate my memory of that aggressively gyrating and pulsating video piece from viewers' encounters with it – but then, works that exist purely 'in themselves' live only in Modernism's fairy tales.

Script, Scribble, and Scratch
I caught myself, for example, expectantly watching as one woman walked up to the piece, a wall of thirteen black-and-white video tubes arranged in a human-sized plus sign – a cross. Perhaps alarmed by the rasping, sniffing, snorting sound emanating from the piece, this woman moved a little tentatively, as if to position herself better – then suddenly stopped, transfixed. It may sound pretentious, but as I watched the reactions to 'Between 1 & 0' it more than once seemed that an invisible electrical field had suddenly developed between viewer and video. Maybe this particular woman was a little startled by her own fascination; as you approach the piece, nothing about its minimalist form, matter-of-fact technology and materials, and its undramatic presenta-tion warns you just how seductive it will be. Even at the moment she stopped dead my viewer may mistakenly have thought she had already grasped the piece in its entirety; that a quick glance from the corner of her eye had been enough to register how it subordinated close-ups of a human body to the discipline of the crucifix. She had probably also noticed that this was not the slow, drawn-out display of the body typical in pornography – the obscene – but rather the rapid, flickering, simultaneous images of lovemaking. Then what struck her, surely, was the inexorable logic of a libidinal economy in which the exploration of a fragmented body leads to an erogenous expansion, to an image of a body whose surface and folds have left the realm of anatomy and blossomed into a single, open, freely structured erogenous zone.

Script, Scribble, and Scratch
She was caught, enthralled. She watched the body as it was broken up, tenderly, its parts becoming interchangeable linguistic signs and symbols. At the same time, seduced by the apparent integrity of the cross shape, these fragments seemed ready to take on coherent meaning. She was sucked into a sinuous, two-fold movement that had no end, and that finally just confirmed all that is script: that the fragment, as she may have

remembered Derrida saying, is script's very form.

Script, Scribble, and Scratch
The images overlapped horizontally and vertically around a shared centre, the centre of the crucifix. Even so, the body on the screens was so fragmented and decentred, for all its intimacy, that the viewer, if only temporarily, became the centre of the work. It reached out to her, and she took in the various levels of its movement and combined them, unconsciously trying to synchronize them with the rasping sound. The sound of what? Maybe a pen, moving hungrily over a sheet of paper, and eagerly producing a text – or, rather, impatiently seeking an image. At the same time, the camera swept slowly and boldly over a body. Every now and then she could make out a part, maybe a hand or a leg, gliding over the skin in another direction; but these slow movements, which were independent of one another, were subordinated to the rapid, fragmented, over-lapping, rubbing, computerized movements of the images, which sometimes seemed synchronized with the sound, sometimes seemed to stumble and lose their bearings – only to recover them again. Or was it the other way around? Could it be that arm, stomach, genitals, back, and teeth – body parts sometimes hard to make out, some-times unmistakeable – emerged through rubbing, and were produced with a pencil? That what was seen was a kind of electronic *frottage*? The ball is back in her court, I thought, remembering Max Ernst's view of *frottage* as a readymade screen for subconscious projections and visualizations. Naturally, I wondered what the visitor whom I was surreptitiously watching was herself projecting onto the screen; but I was soon distracted by the image this double projection in itself provoked.

Script, Scribble, and Scratch
Hill's attempt to deconstruct the distinction between inside and outside – his ability to create works that keep turning themselves inside out, like a Möbius strip – has never been more clearly and coherently articulated. His 'Crux', 1983-86, is an obvious precursor in this respect, a kind of performance piece in which Hill mounted five cameras on his body so as to register the movements of his hands, feet, and head as he moved through a land-scape. In the installation, the cameras are replaced by monitors, also in a cross, to suggest a crucifixion. Performer and camera operator are one; the subject is present but the centre is absent. The one-channel piece 'Site Recite (A Prologue)', 1989, is another forerunner; its last shot is taken literally from

*Exhibited in the exhibition *Passageworks* at the Rooseum, Malmö, 27 April - 25 July 1993.

opposite
Between 1 & 0, 1993, installation at the Rooseum, Malmö, Sweden

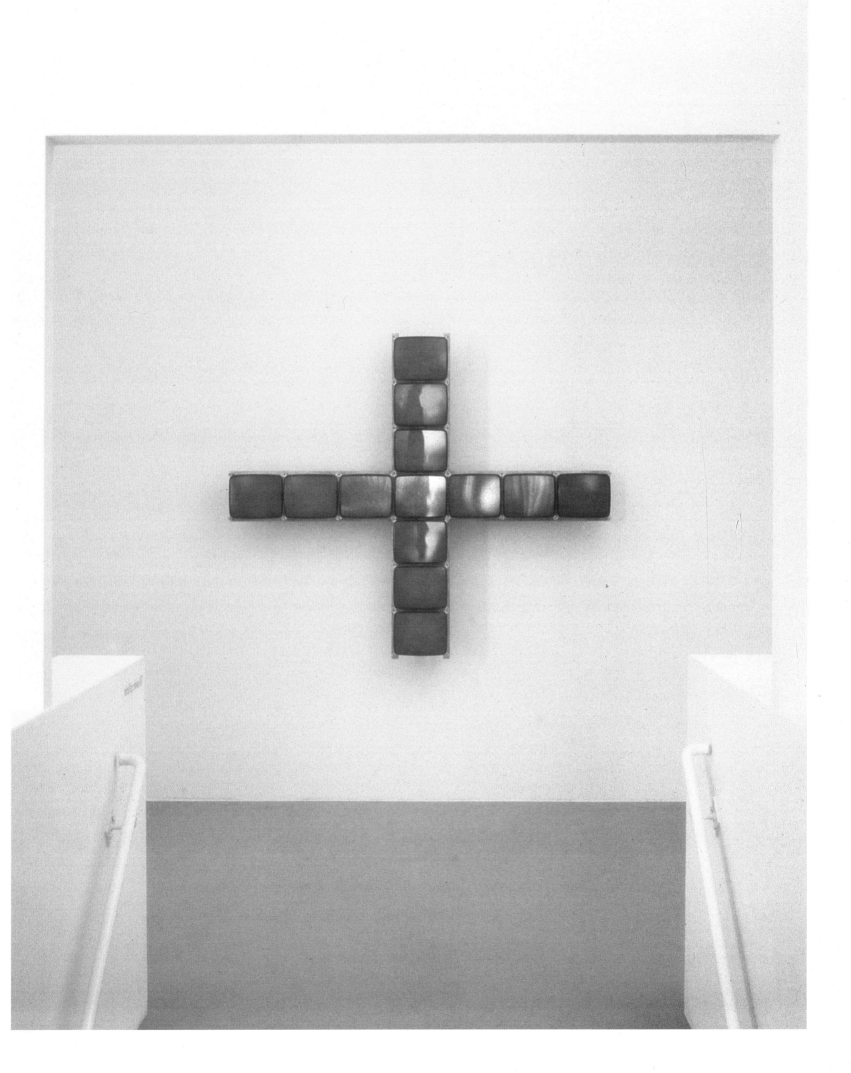

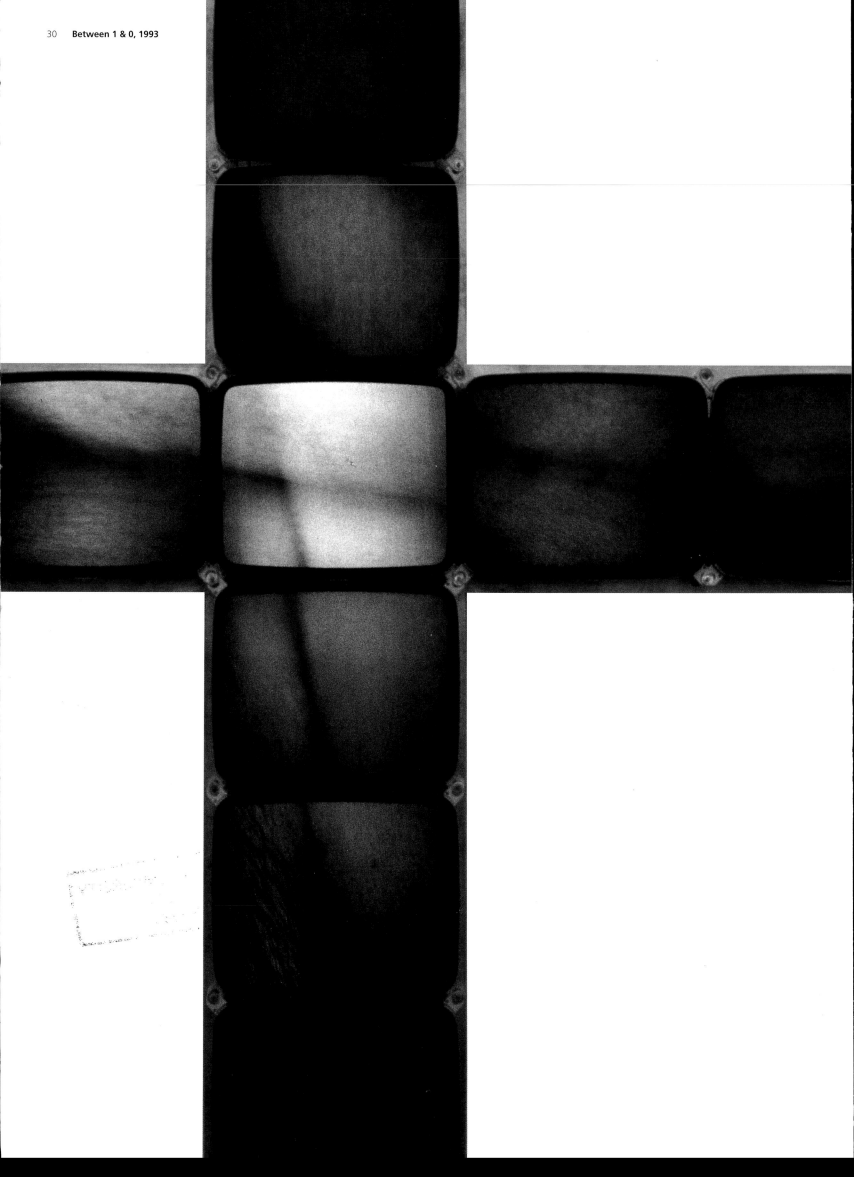

inside the body – from the throat, beyond the
mouth we have heard throughout the piece.
Again, the tape is transformed into a Möbius
strip; though there is still an inside and an
outside, they are indistinguishable.

Script, Scribble, and Scratch
In 'Between 1 & 0', the deconstruction of this
dichotomy between inside and outside,
subject and object, is 'personified' and
'demetaphorized'. The artist's hand has
guided the camera over the body, but this
camera is the pencillike sort usually used in
medical procedures. With the apparently
thoughtless, intimate kind of physicality and
automatism we show when we absentmind-
edly scratch ourselves, it visits and scrutinizes
parts of the body never usually seen, only felt.
The body my viewer saw was paradoxically
viewed as if from the inside – yet here it was
on the surface, the cool surface of the video
screen. At some level the experience evoked
the paradoxical combination of physicality
and filmic distance that one feels in a fever.
Maybe this was what kept that woman spell-
bound, and kept both her and me in our
respective places: Hill's operation – in both
senses of the word – brings about a fusion, or
a confusion, between opposites, while never
pretending to erase them.

Script, Scribble, and Scratch
'Between 1 & 0' functions (in one of Derrida's
many useful key expressions, and one that
seems natural before these flickering folds of
skin) as a 'hymen' between inside and
outside: between feeling and surface, body
and language, whole and part; all the
hierarchically arranged dichotomies we
construct to orient ourselves in our lives.
Metaphorically, the hymen is the
consummation of marriage; literally, on the
other hand, its presence denotes the absence
of consummation. The hymen is a marriage, a
fusion, that abolishes both contrasts and the
difference between them. It is also a mem-
brane; the hymen between opposites is both
what connects them and what keeps them
separate. 'The hymen "takes place"', Derrida
writes, 'in the "inter", in the spacing
between desire and fulfilment, between per-
petration and its recollection'. It takes place,
viewer and I would like to add, between pres-
ence and absence – 'Between 1 & 0'.

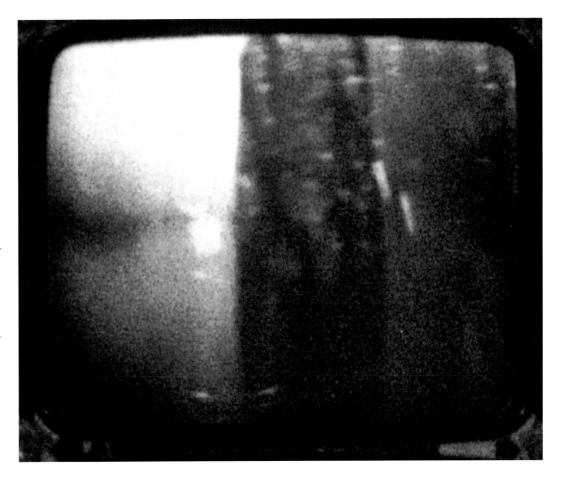

Standing Still On the Lip of Being

Robert Mittenthal

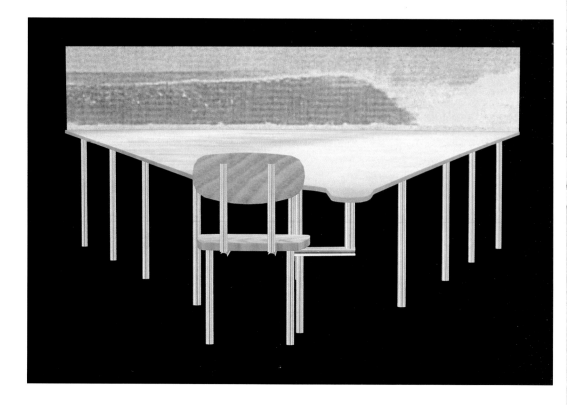

In his preface to Stephen Sarrazin's book *Surfing The Medium*, Gary Hill reveals his surfing roots and acknowledges the presence of 'the surfing mind' in many of his works. A surfing mind may sound a bit 'kooky' to the uninitiated, but it does make sense in relation to how Hill describes surfing's *green room*: 'It is the moment of ecstasy – being inside the question that asks of itself while revealing itself'. This process of immanent revealing is what drives Hill. From the chaos of ocean, waves are revealed. This is as religious as Hill gets. He has educated himself in the reading of these revelations.

When the surfer stands and looks down the face of the wave he knows he is on the way to being there. He is lifted in the process of entering the extant question of Being. It is not about whether he makes it to the green room or not, for it's all grounded in the process of becoming with the wave. Is not the television display with its spray of information another green room of sorts that we've lost control of, that has 'closed out'? (The surfing term for waves that are too big for a particular location and collapse without any form.)[1]

Hill's description of the green room is linked to Heidegger's notion of clearing, that moment when the 'obscuring curtain of things' is lifted. Indeed, Hill's preface opens with a quotation that foregrounds his involvement with Heidegger. These first few words from Marshall McLuhan would make a fitting tabloid headline: 'Heidegger surfboards along the electronic wave as triumphantly as Descartes rode the mechanical wave'. In 'becoming with

the wave' Hill tucks Heidegger underarm and heads out into the electronic surf.

With 'Learning Curve', Hill is trying virtually to enact that perfect wave that 'appears to stand frozen in its own becoming as if it were requesting existence from the world'. Hill has designed an industrial-strength school chair to support a huge desktop that resembles a desert or beach, rising up and out till it reaches a curved wall that forms the horizon-line for a looped projection of a seemingly endless breaking wave. The expanse of whitish stained wood emphasizes the separation between viewer and image, between the material (chair) and the immaterial (wave image).

Besides the obvious reference to surfing, 'Learning Curve' puns on the slide-in functionality of the school chair, which wraps around the student in a suggestive *curve* and, if viewed from above, resembles a cross-section of a wave. While a *learning curve* is a projection or quantification of how quickly someone will be able to acquire a particular skill or ability, video feedback resembles a kind of *learning* in that it involves a dialogue between being and becoming. Hill describes

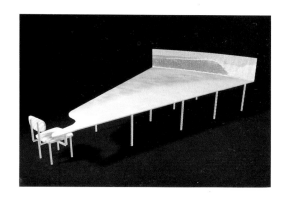

this nearly instantaneous feedback loop as a 'near future' that simultaneously absents and makes present the camera's subject.

'Learning Curve' has an imposing presence which calls up particular narrative associations. To students forced to sit through hour after hour in room after room, the school classroom can become a kind of dystopia, whose artificial, imposed structure can only be overcome by the mind. Faced with 'Learning Curve', one might think of an interactive video game, but here, instead of losing oneself in the thrill of trying to survive in a rigidly rule-governed visual space, we are faced with an image of relentless steadiness. There is no game and no diversion, only a kind of confrontation between chair and wave. One may well wonder: something is there, but is anything happening?

To sit in 'Learning Curve' is to become part of the piece; one is physically supported by the same object that focuses one's attention on the pure visual space of the projected wave. The chair forces the viewer into a single-point perspective, where time seems slowed down. Conversely, speed is exactly what television relies upon to eliminate the time to think. In 'Learning Curve', sensory diversions are minimized, so that one's perception of the wave easily becomes abstracted or estranged. Heidegger suggests that in order to see the truth in mere things, just such an abstraction is necessary.

Much closer to us than all sensations are the things themselves. We hear the door shut in the house and never hear acoustical sensations or even mere sounds. In order to hear a bare sound we have to listen away from things, divert our ear from them, ie, listen abstractly.[2]

This renewal of perception is at the heart of Heidegger's claims about art. However, Hill is not interested in renewing the viewer's perception of a wave, nor in helping us see what makes the wave wavy. Rather, Hill wants the viewer to see something else, to find a mental path, any mental path, but not one that he would want to predict or dictate.

If we are able to see the wave abstractly, we may be, following Heidegger, on the way to thinking. The desktop physically connects the viewer to the projection of the wave at the same time as it separates him or her from it. Sitting in the frame of this chair, another perceptual frame opens; one enters the ground of the piece, where seeing can become 'a sort of touch ... a contact at a distance'.[3] If 'Learning Curve' is about anything, perhaps it is about one's ability to read and write one's self. Those who insist only on looking will likely be baffled and disappointed.

The second piece of the series, 'Learning Curve (Still Point)', uses the same school chair design, this time with an extended desktop that narrows to a point, resembling an old fashioned surfing long-board. In what from some perspectives seems like an optical illusion, a disproportionately small monitor sits precariously out on the toe of the board, spitting light out at us from an image of the green room. One imagines a Californian schoolboy daydreaming of surfing, suddenly called upon to answer one of his teacher's queries. 'Still Point' suggests the physical motion of standing to answer. If the secret of poetry is, to paraphrase poet Charles Olson, learning to dance sitting down, one can say that 'Still Point' invites us to leap upon the desktop and ride our minds wherever they might take us.

The third piece in this series, 'Learning Curves', is a proposed installation for the École Nationale Supérieure de Mécanique et l'Aéronautique in Poitiers, France. Hill has designed an extended desktop that will connect four or five chairs similar to those used in the first two pieces. However, unlike the flat surfaces of these desktops, here the desktop will be shaped by the interactions of the various chair-sites. Hill proposes to make an analogue for the complexity of wave currents. There will be one monitor for each chair to serve as mirror for the viewer to contemplate. According to Hill, the perspective each chair provides is to be isolated from the other chairs' perspectives. This echoes Maurice Blanchot's fascination with the solitary gaze. Hill wants to elicit an interminable gaze, 'when what is seen imposes itself on your gaze, as though the gaze has been seized, touched, put in contact with appearance...'.[4]

This is not the first time Hill has used a single-point perspective in an installation. For 'In Situ' (1986), he positioned a monitor, speakers, four fans and a spotlight so that they focused on a single armchair. The chair invited the viewer to sit down with a curious 'too-small' seat cushion, as if this cushion were a frame within the larger frame of another armchair. Photocopies of images from the video float down to a rug, which is cut in the dimensions of a television monitor. The videotape begins with images of Hill's eye blinking, as if something horrible had entered it. Images of Hill reading and trying to eat are interrupted by a loss of equilibrium. As if tumbling off a wave, Hill falls, pulling a tablecloth with everything on it down with him. Voices from the then current Iran-Contra hearings are slowed down so that they seem disembodied. When the monitor switches off unexpectedly, we are left in silence, looking at ourselves in the reflection of the empty tube, the remnants of the 'news' on the floor around us. When the video suddenly returns, it is each time in a smaller frame.

'In Situ' goes to great lengths to physically confront the viewer with various events, from the shrinking start/stop news images on the monitor, to the paper erratically jettisoned and blown around the room by the fans, to a sound source hidden beneath the seat cushion. Forcing the viewer to see where she sits, 'In Situ' literally jars her out of the seat. In contrast to this framing frenzy, 'Learning Curve' employs far less aggressive means to alienate the viewer. Creating an immobility that he hopes will fascinate and/or disturb us, Hill pursues what Blanchot calls the 'ultimate

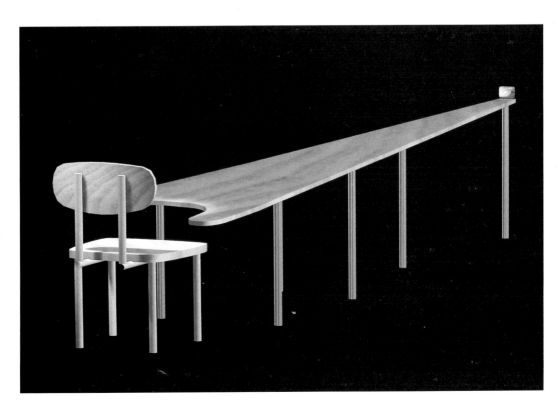

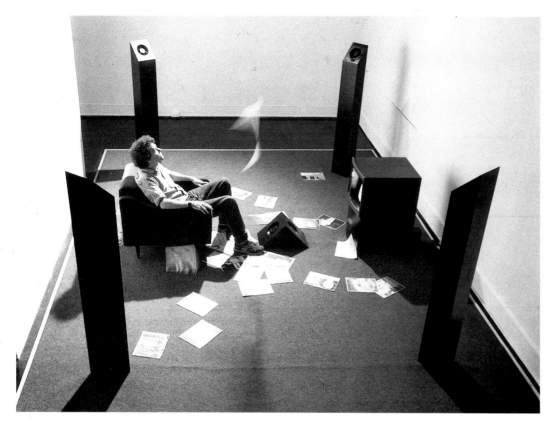

GARY HILL *In Situ* 1986, installation

form of communitarian experience, after which there will be nothing left to say, because it has to know itself by ignoring itself'.[5] Mirroring the viewer's position, 'Learning Curve' and 'Still Point' provide sites for thinking, inviting us to lose ourselves in our own gaze.

In Michael Snow's film *Wavelength* the camera takes a real-time plunge into a photograph of waves. This sudden climax occurs when, after more than half an hour, the picture frame finally reaches the water, leaving the viewer gasping for air. Conversely, 'Learning Curve' resists any sudden climax, presenting a wave ceaselessly curling toward us. Hill's 'Learning Curve' series invokes a steady state, all middle ground, where there is neither beginning nor end, where there is no climax (or all climax).

Hill's suspicion of visuality is an undercurrent in many of his works: 'If I have a position, it's to question the privileged place that image, and for that matter sight, hold in our consciousness'.[6] Like the Greeks, we tend to think of understanding as a kind of seeing. While most video disembodies sight, relying on the image to titillate the viewer, Hill foregrounds the physical *seeing* of the image. He would remind us that the eye is flesh and that the body is both perceiver and perceived, both subject and object. This separates him from those who, after Blake, enamoured of the image, pursue a kind of *received* or visionary experience. Against Blake's infinite Vision, Hill proposes that we imagine 'the brain closer than the eyes'.[7]

NOTES

1. Gary Hill, preface to Stephen Sarrazin's *Surfing the Medium*, Chimaera Monograph: Edition du Centre International de Création Vidéo Montbéliard Belford, 1992, p.9. (Other uncredited citations are from his preface on pages 8 and 9.)
2. Martin Heidegger, 'The Origin of the Work of Art', in *Basic Writings*, New York, 1977, p.156.
3. Maurice Blanchot, *The Gaze of Orpheus*, Barrytown NY, 1981, p.75.
4. Ibid, p.75.
5. Maurice Blanchot, *The Unavowable Community*, Barrytown, NY, 1988, p.25.
6. Interview with Stephen Sarrazin, in *Surfing the Medium*, op. cit., p.84.
7. Gary Hill, 'Site Recite' script, quoted in *Gary Hill*, Paris: Editions du Centre Pompidou, 1992, p.32. Hill's reference to 'dormitories of perception' in this text plays off Blake's 'doors of perception'.

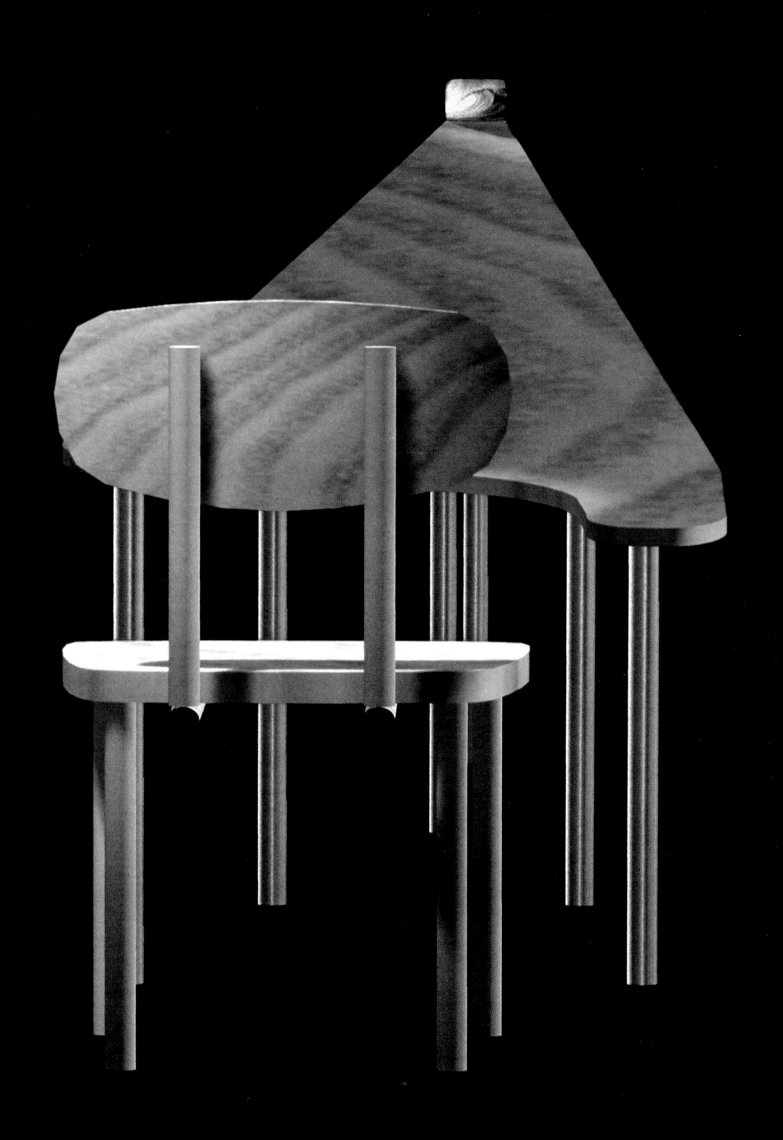

Gary Hill: exhibitions and bibliography

Selected Solo Exhibitions since 1990

1990 Galerie des Archives, Paris
Galerie Huset/Ny Carlsberg Glyptotek,
Copenhagen
YYZ Artist's Outlet, Toronto
Museum of Modern Art, New York

1991 Galerie des Archives, Paris
OCO Espace d'Art Contemporain, Paris
Nykytaiteen Museo, Helsinki

1992 *I Believe It Is an Image*, Watari Museum
of Contemporary Art, Tokyo
Le Creux de L'Enfer, Centre d'Art
Contemporain, Thiers
Touring exhibition organised by Musée
national d'art moderne, Centre
Georges Pompidou, Paris, touring in
1993 to IVAM Centre Julio Gonzalez,
Valencia; Stedelijk Museum,
Amsterdam; Kunsthalle Vienna
Stedelijk Van Abbemuseum, Eindhoven

1993 Donald Young Gallery, Seattle
Sites Recited, Long Beach Museum of
Art, California

Selected Group Exhibitions since 1990

1990 *Energieën* Stedelijk Museum,
Amsterdam
Video Poetics, Long Beach Museum of
Art, California
Passages de l'Image, Musée national
d'art moderne, Centre Georges
Pompidou, Paris, touring in 1991 to
Barcelona; Columbus, Ohio and San
Francisco
L'Amour de Berlin: Installation Video,
Centre Culturel, Cavaillon, France
Bienal de la Imagen en Movimento '90,
Centro de Arte Reina Sofia, Madrid

1991 Biennial Exhibition, Whitney Museum
of American Art, New York
Currents, The Institute of Contemporary Art, Boston
The Body (2), The Renaissance Society
at the University of Chicago
Metropolis, Martin-Gropius-Bau, Berlin
Topographie 2: Untergrund, Wiener
Festwochen, Vienna
Artec 91, International Biennale,
Nagoya
*Glass: Material in the Service of
Meaning*, Tacoma Art Museum, Washington

1992 *Doubletake: Collective Memory & Current Art*, Hayward Gallery, London, touring in 1993 to Kunsthalle Vienna
Donald Young Gallery, Seattle
Documenta IX, Museum Fridericianum, Kassel
Art at the Armory: Occupied Territory, Museum of Contemporary Art, Chicago
Japan: Outside/Inside/Inbetween, Artists Space, New York
The Binary Era: New Interactions, Musée D'Ixelles, Brussels, touring in 1993 to Kunsthalle Vienna
Performing Objects, Institute of Contemporary Art, Boston
Metamorphose, St Gervaise-Genève, Geneva
Manifest, Musée national d'art moderne, Centre Georges Pompidou, Paris

1993 *Biennial Exhibition*, Whitney Museum of American Art, New York, touring to Seoul in 1993
The 21st Century, Kunsthalle Basel
American Art in the 20th Century, Martin-Gropius-Bau, Berlin; The Royal Academy, London
Passageworks, Rooseum, Malmö

Eadweard Muybridge, Bill Viola, Giulio Paolini, Gary Hill, James Coleman, Ydessa Hendeles Art Foundation, Toronto
Fifth Fukui International Video Biennal, Fukui, Japan
Strange HOTEL, Aarhus Kunstmuseum, Denmark

Selected Bibliography since 1990

The artist refers interested readers to the texts in the following catalogues, given in their English language versions where possible:

1990. *Gary Hill*, Galerie des Archives, Paris. Robert Mittenthal, 'Reading the Unknown: Reaching Gary Hill's *And Sat Down Beside Her*'.

1991. *Between Cinema and a Hard Place*, OCO Espace d'Art Contemporain, Paris. Jacinto Lageira, 'Sprachen Video' (in French).

1991. *Passages de l'Image*, Fundacio Caixa de Pensions, Barcelona. Jacques Derrida, 'Videor', in English translation.

1992. *Gary Hill – I Believe It Is an Image*, Watari Museum of Contemporary Art, Tokyo. Stephen Sarrazin, 'Channeled Silence (Quiet, Something 'is' Thinking)' and Gary Hill, 'Leaves'.

1993. *Passageworks*, Rooseum, Malmö. Stephen Sarrazin, 'In a Crowded House'.

1993. *Gary Hill*, IVAM Centre Julio Gonzalez, Valencia. Jacinto Lageira, 'La imagen del mundo en el cuerpo del texto', and Hippolyte Massardier, 'Con unas y dientes', both with English translations.

1993. *Gary Hill*, Stedelijk Museum Amsterdam/Kunsthalle Vienna. Lynne Cooke, 'Gary Hill: Beyond Babel'; Gary Hill, 'Inter-view' and 'Between 1 & 0'; George Quasha, 'Tall Acts of Seeing' and Willem van Weelden, 'Primarily Spoken'.

Sponsors and Donors